THINGS to LOOK FORWARD TO

52 LARGE AND SMALL JOYS FOR TODAY AND EVERY DAY

SOPHIE BLACKALL

CHRONICLE BOOKS
SAN FRANCISCO

Library of Congress Cataloging-in-Publication Data

Names: Blackall, Sophie, author.
Title: Things to look forward to : 52 large and small joys for today
 and every day / Sophie Blackall.
Description: San Francisco : Chronicle Books, [2022]
Identifiers: LCCN 2021046671 | ISBN 9781797214481 (hardcover)
Subjects: LCSH: Joy. | Enthusiasm. | Hope.
Classification: LCC BF575.H27 B5478 2022 | DDC 158.1--dc23
LC record available at https://lccn.loc.gov/2021046671

Manufactured in China.

Design by Allison Weiner.

10 9 8 7 6 5 4 3

Chronicle Books LLC
680 Second Street
San Francisco, California 94107
www.chroniclebooks.com

Chronicle books and gifts are available at special quantity
discounts to corporations, professional associations, literacy
programs, and other organizations. For details and discount
information, please contact our corporate/premiums department
at corporatesales@chroniclebooks.com or at 1-800-759-0190.

INTRODUCTION

I have always been a cheerful sort of person, able to find the silver lining in just about any cloud, but 2020 was a son-of-a-cumulonimbus. There was the pandemic, of course, which knocked us all sideways. Like most people, I tried to remain hopeful, counting my blessings, grateful to be alive when so many were dying. But also like most people, I was full of anxiety and fear and grief and uncertainty. My partner, Ed, and I worried about bills, fretted about my aging parents, and missed our kids, who were living away from home. Deciding to downsize, we moved out of the apartment we had happily rented for ten years with our blended family, the longest either of us had ever lived anywhere. We canceled our wedding, because we knew we couldn't get married without our loved ones. Then in the fall, Nick, the dear, queer father of my children, died in an accident on the other side of the world. The thunderclouds really closed in then, and for a while I struggled to find any rays of hope. I almost lost sight of beauty and wonder and delight.

One morning, standing under a hot shower, I decided I needed to make a list of Things to Look Forward To. I thought perhaps other people might need such a list too, and maybe they could collect their own things, and together we would build a whole stockpile. No matter how gloomy the clouds, I told myself, there is always something bright

on the horizon—even if we have to squint to see it. Even if we have to create it ourselves.

As I compiled my list, I realized that many of these things could be done right away. There is pleasure in anticipation, but also in instant gratification.

I posted the first batch with drawings on Instagram, and the response was quite something. I received dozens and dozens of pictures of eggs with faces on them. People told me their favorite bits of their favorite books. They baked muffins and delivered them to neighbors and first responders. They told me about things they had learned and things they wanted to learn. Their new skills inspired others, who vowed to take up whittling or brewing. We were doing the things, even as we were looking forward to them.

I have often found myself romanticizing the Before Times, when we could travel the world and hug our friends and shake hands with strangers, but I have come to the conclusion that it's better to look forward: to gather the things we've learned and to use our patience and perseverance and courage and empathy to care for each other and to work toward a better future for all people. To look forward to things like long-term environmental protection and racial justice; equal rights and an inclusive society; free health care and equitable education; an end to poverty, hunger, war. But we can also look forward to everyday things that will buoy our spirits and make us laugh and help us feel alive and that will bring others comfort and hope. I hope this list will give you some Things to Look Forward To, and if you hate tidying up

or take offense at flowers that look like furry brains, you can tear out those pages and insert your own. Or better yet, make your own list.

Perhaps you'll even share it with me. I look forward to that!

THE SUN COMING UP

President Barack Obama once said, "No matter what happens, the sun will rise in the morning."

It's true and worth remembering. Even if it's temporarily behind a cloud, the sun will come up, and a new day will dawn.

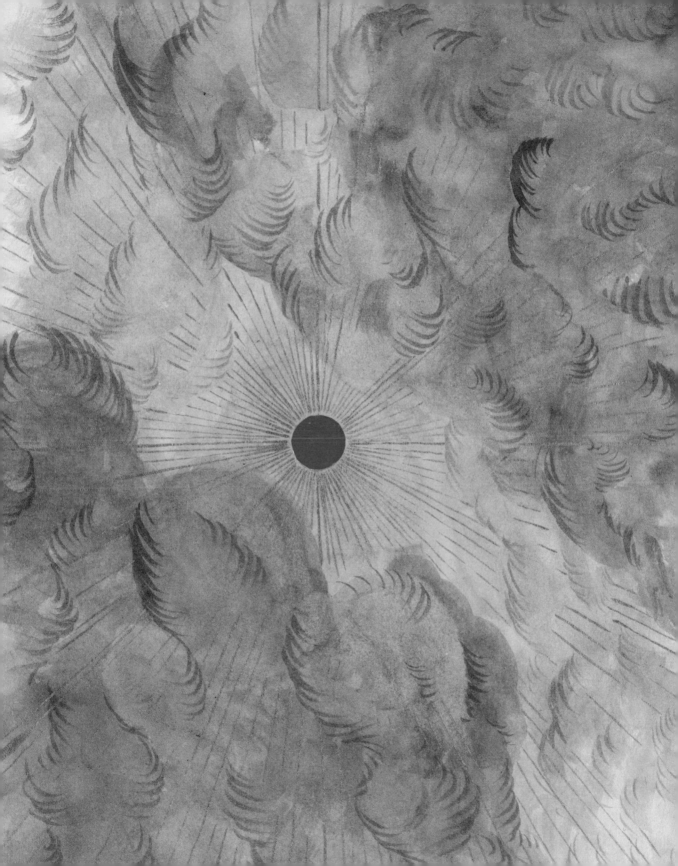

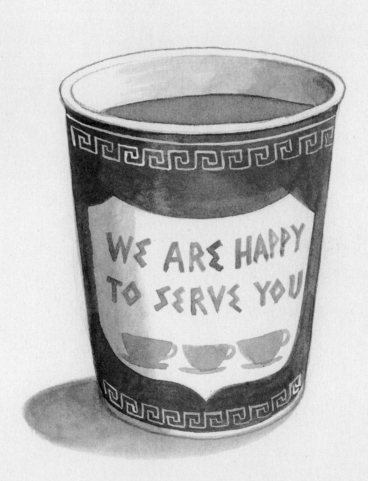

COFFEE

When I ask people what they look forward to in life, the answer I hear more than any other is coffee.

The coffee-making process is part of the pleasure for lots of people: the release of yesterday's compressed puck of spent grounds, the grinding of fresh beans, the anticipation of the first sputtering hiss from the espresso spout or the first gurgling drip of the percolator. Or they look forward to a beloved coffee cart on a favorite street corner, an alluring barista, or a trusted thermos that takes the edge off the early-morning dog walk. Coffee is the boost we need to get going— and to keep going.

My friend Melissa tells me she has a fancy new coffeepot and has started going to bed earlier and earlier so that the morning will come sooner.

Some people like tea, but it's not the same. Not at all the same.

A HOT SHOWER

I never take a hot shower for granted and never underestimate its power to make me feel better. Coming from drought country, I mostly try to keep my showers short. But now and then I let the hot water run.

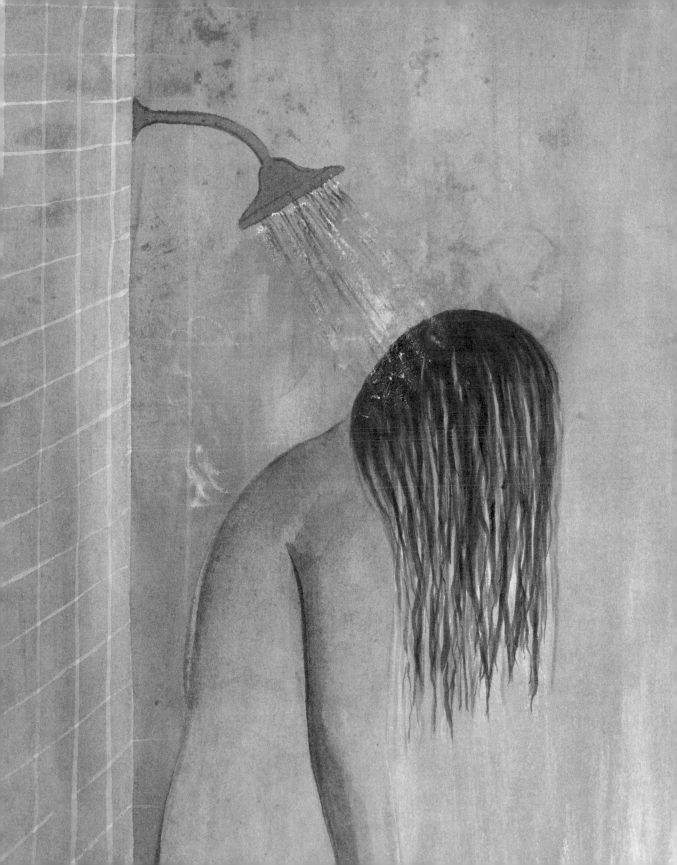

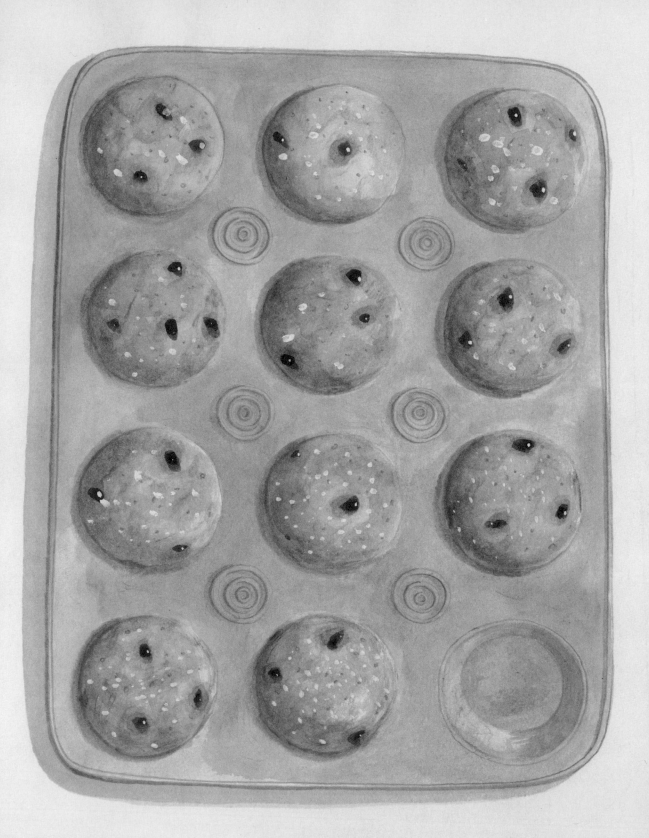

BAKING SOMETHING FOR SOMEONE

We have carpenters working on our barn, and I look forward to baking them muffins. I made the first batch the day the weather changed. The men were on the roof. Frost was on the ground. The muffins were warm.

I handed them over, and the builders made involuntary, groaning sounds.

I made another batch the next day.

On the third day, I didn't have time and showed up empty-handed. The men made the same involuntary sounds, but their shoulders slumped and their knees sagged. So now I try to bring them every time.

But each morning, when I put the cold butter in the bowl with the sugar and begin to work it with the wooden spoon, I go through the same cycle of thoughts:

My hand hurts.

This is way too hard.

Oh, for a KitchenAid!

Why am I doing this? I could pick up some Little Debbie cakes.

I should be finishing my book, not trying to forcefully combine things that want to stay separate.

They'll never come together.

What a terrible idea.

But then . . .

Oh.

Oh!

It's alchemy!

The rest is easy, and I pull the muffins out of the oven and drive them over and eat one on the way to make sure they're OK. At this point, the workers are probably sick to death of muffins and too polite to say so. But I've noticed the muffin days are always more productive. For me, that is.

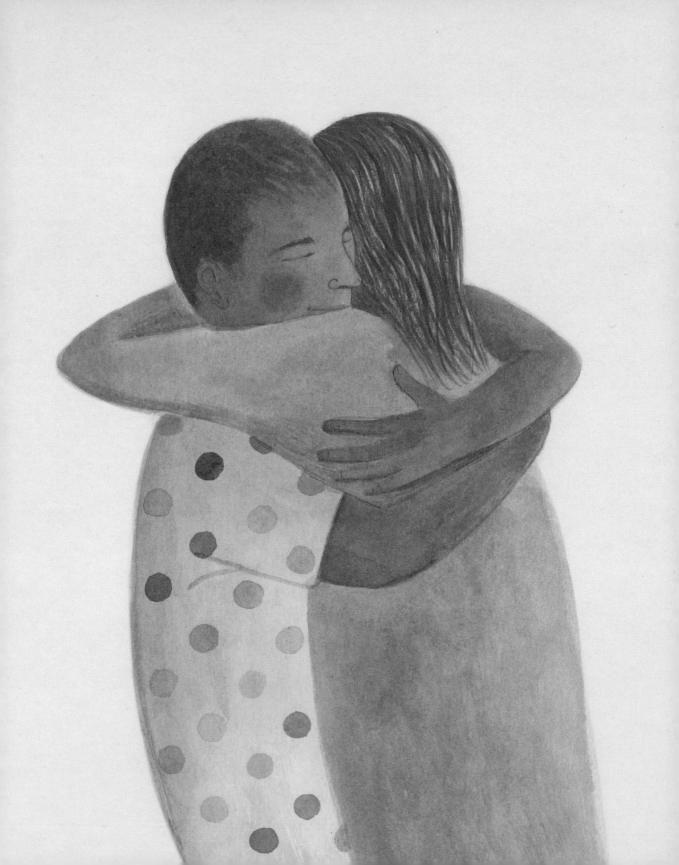

HUGGING A FRIEND

It was only during the pandemic when I couldn't hug anyone that I realized how much I missed it. My friends and I hug to celebrate something good, and we hug to commiserate when things are bad. I hug my grown children and remember when they fit in my arms; I hug my parents and almost remember fitting in theirs. I hug my bony ninety-two-year-old friend very gently, and I hug my friend's giggly baby robustly. And I look forward to their hugs in return.

LEARNING SOMETHING NEW

My friend Kirsten is teaching herself to carve exquisite wooden spoons. Melissa is learning how to espalier pear trees in her Brooklyn backyard. My seventy-six-year-old stepmother is perfecting tumble turns in an ocean pool. When I asked on Instagram what new things people have learned, I received an incredibly ambitious and inspiring list: sign language, Norwegian, how to bake bagels, how to say no. They learned to be patient. To live with people in small spaces. To teach children while working from home. To make do on less. To not panic. To remain hopeful. We can always look forward to learning something new. Even if it's just a word.

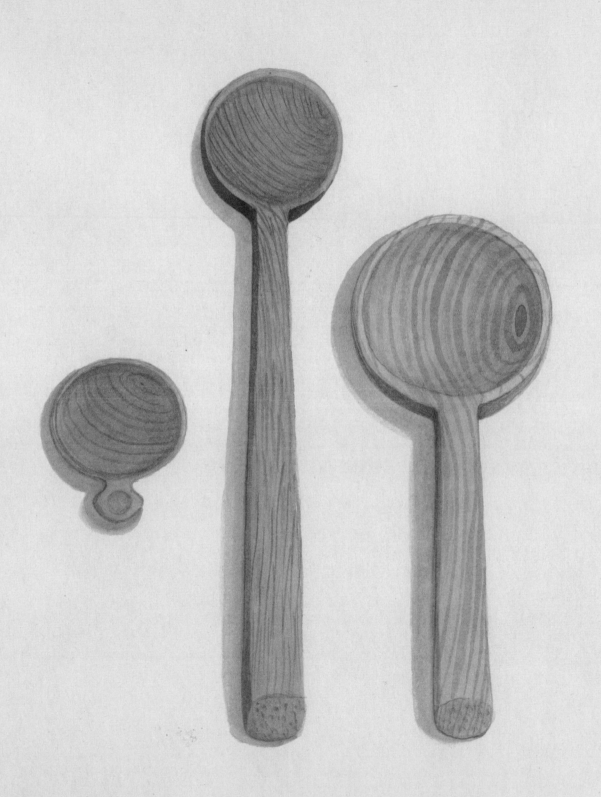

A NEW WORD

My father has a steel-trap memory and a vast vocabulary. The show-off. But even he comes across an unfamiliar word now and then. And he texts it to me, and I try to find him one in return. Words like *staffage*, the little figures in a landscape painting; or *tittle*, the little dot over or under a letter; or *fulvous*, a nicotine yellow; or *hispid*, meaning "covered in bristles." Our goal is to use them casually in conversation. I discover words that are new to me every day, but I look forward to the challenge of finding one for my father.

APPLAUSE

Uniting with strangers, sharing an experience, and expressing our joy in collective applause is one of life's pleasures. But even when we can't go to the theater or concerts or elementary school talent shows, we don't have to stop clapping. We can applaud essential workers at the end of the day. We can applaud the postal worker who brings our mail. When our ducks were learning to fly, we clapped when they landed at our feet. I applaud the mountain for its brilliant transformation into copper and gold. Well done, Mountain, well done!

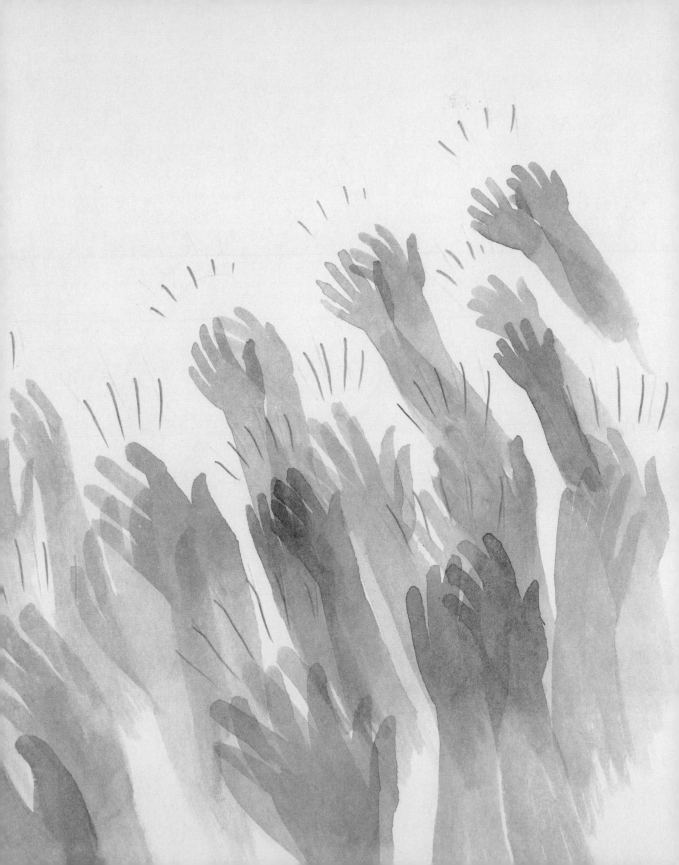

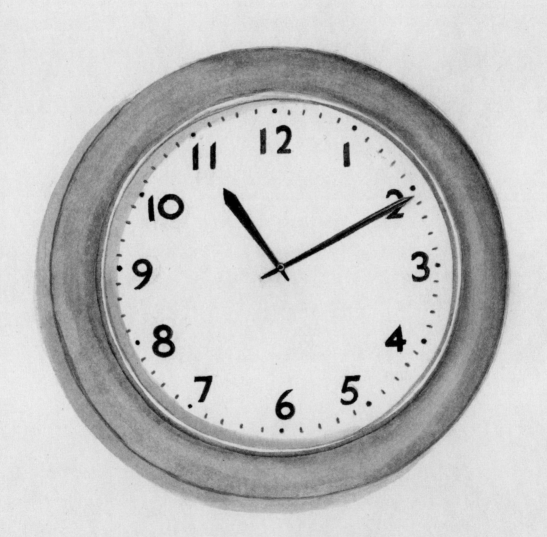

11 : 11

When my kids were little, we would touch fingertips like E.T. and Elliott and make a buzzing sound when we connected. I would reach a hand to the back seat when I was driving, and the kids would *bzz* my fingertip in return, not looking up from their books. I would *bzz* them if I was stuck on the phone too long or if I was trying to be discreet at school drop-off. It was a way to silently communicate: I love you. Don't forget to eat your fruit. I wish I could protect you from all the heartache and injustice in the world—*bzz bzz*. We haven't entirely retired the finger buzz, but it was mostly replaced around fifth grade with marking 11:11. Initially, it was about noticing the time and making a wish; all the kids were doing it. In middle school, when my children got cell phones, one or the other would send a family group text at 11:11 a.m. I was torn between thinking they shouldn't have their phones out and being chuffed to get the message. Now they are out of college and making their way in the world, but we three still text each other at 11:11 if we happen to catch it, sometimes twice a day. You can't watch for it—that would be wrong—but it's a moment to look forward to, a moment of connection. A virtual finger buzz.

FIRST SNOW

Growing up in Australia, I didn't see falling snow until I moved to the United States. After twenty years, it's no longer a novelty, but I always look forward to the first snow. If you're outside, you can tell it's coming. The sky lowers itself like a goose on her eggs, and everything grows very quiet. Then a snowflake flutters down, and another, and soon they are swirling about like the aftermath of a pillow fight.

 In the country, the landscape sparkles like a Victorian Christmas card. You can go outside in the first snow and tramp about, then come indoors, light a crackling fire, make a hot toddy, and revel in coziness. In the city, falling snow causes everyone to slow down for a minute. Everything is beautiful, and the children are happy. It's hard to argue with that.

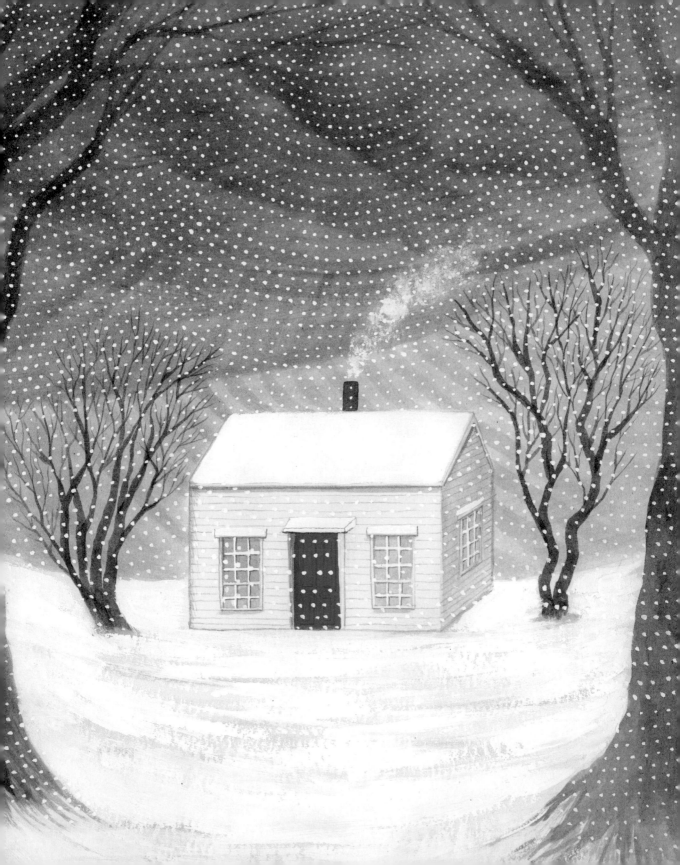

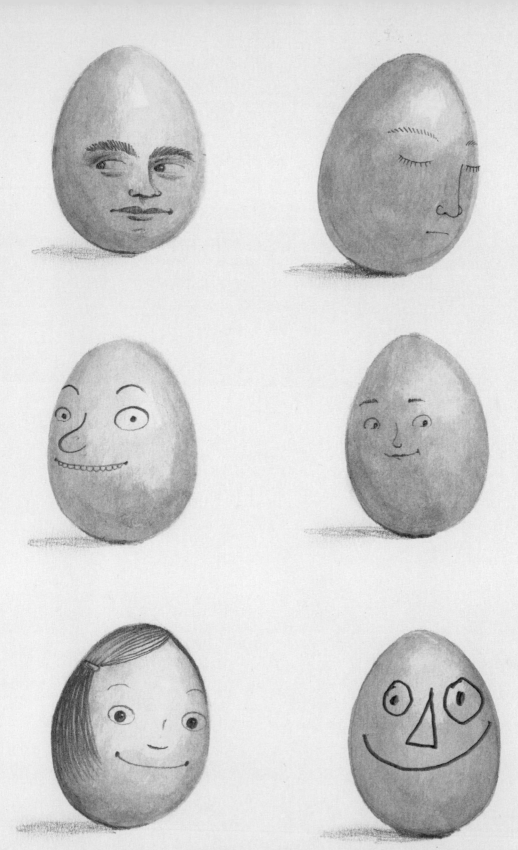

DRAWING ON EGGS

If you have an egg in your house, you can draw a face on it. No one will stop you. Then you will look forward to opening the fridge.

"Hello, Egg!" you'll say.

You will amuse yourself no end. Trust me.

A CUP OF TEA

If coffee is the boost that propels you into the day, a cup of tea is the soft landing when you inevitably come back down. Comforting, reassuring, procrastinating tea. Sometimes the idea of tea will suffice; it's enough just to put the kettle on.

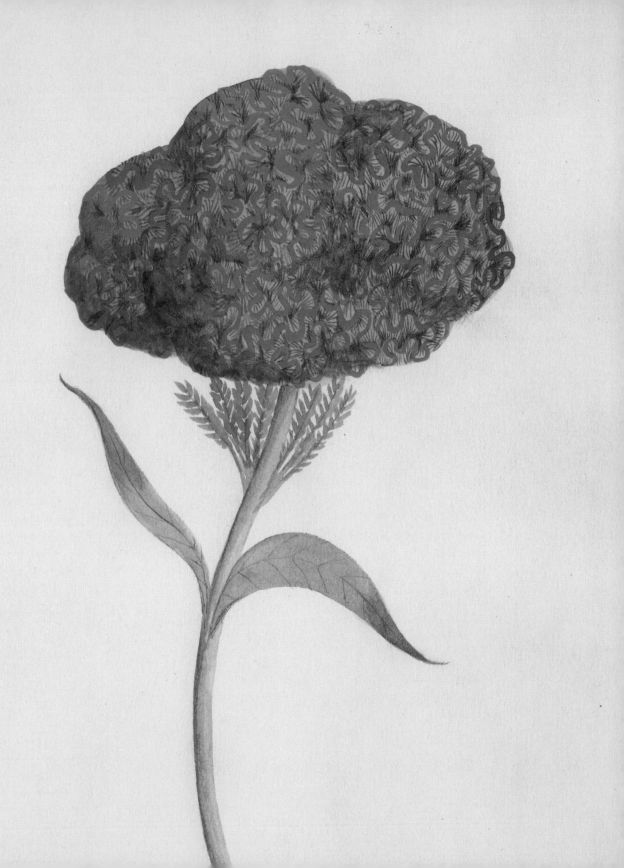

FLOWERS THAT LOOK LIKE BRAINS

Cockscombs (or celosia) are a sturdy sort of flower. You can pat them.
If your head hurts, they might make you feel a bit better.

LISTENING TO A SONG YOU'VE HEARD BEFORE

When I was in the supermarket the other day, in the aisle with the light bulbs and the matches and the scouring pads, "Wichita Lineman" came on the store radio. I thought of Nick—my best friend; then my husband; then my ex-husband; now my late much-missed ex-husband—and how he used to love this song, even though he thought it was about a witchy, tall lion man, back before we could google lyrics. He used to love to sing all the morse code bits, and for nearly three minutes the other day in aisle 6, I was twenty-one again, driving on a dusty road in Outback Australia, and Nick was singing *dit-da-dit-da-dit*s. Songs can do that to you.

SCATTERING WILDFLOWER SEEDS

If you know a place with a patch of dirt, you can scatter some wildflower seeds there in the early spring and wait for the rain, or sprinkle some water, and then forget all about it. And a few weeks later you will be met with a patch or a swath or a whole field of flowers: cornflowers, maybe, or Queen Anne's lace or poppies. Then you can imagine you are Helena Bonham Carter with a parasol, about to be kissed in a Tuscan field. And if you pick the flowers, more will grow. You can collect their seeds at the end of summer and look forward to scattering them next year.

A FLOCK OF BIRDS

When we were kids, in the car or on a walk, my brother and I would keep our necks craned to the sky, looking for a flock of birds. If we saw one, our mother would say, "Flock of birds before my eyes, when will I get a pleasant surprise?" And we would rush to supply the time. "A quarter past four!" "Two Saturdays from now!" "When we turn the corner!"

I don't remember how often our predictions resulted in accurately scheduled pleasant surprises, but I do remember sometimes trying to engineer them by picking flowers or making our mother a cup of tea. It was well-intentioned but—let's face it—cheating.

These days I don't hope for a surprise when I see a flock of birds, but an unfettered flock of birds darting and swooping, converging and dispersing, chattering together, gathering to fly far away is something to look forward to. I wonder where they'll go and if they'll come back.

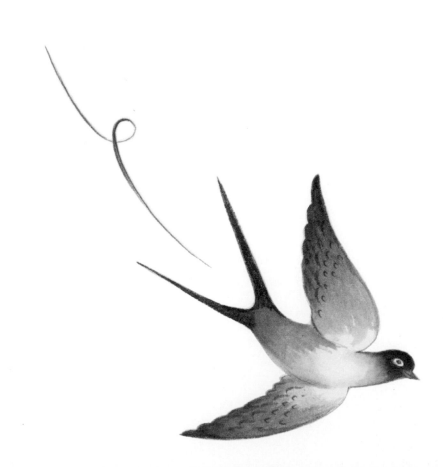

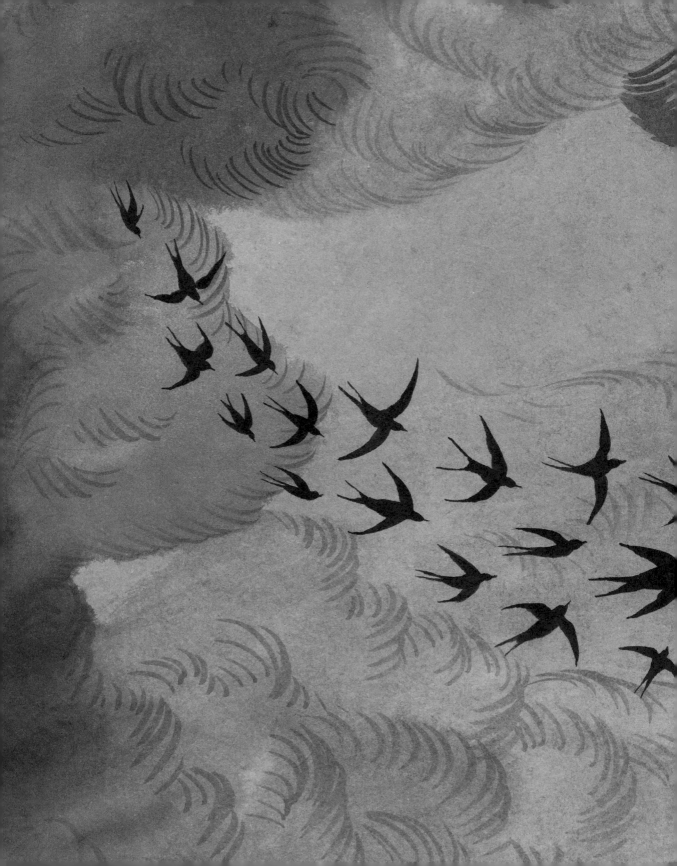

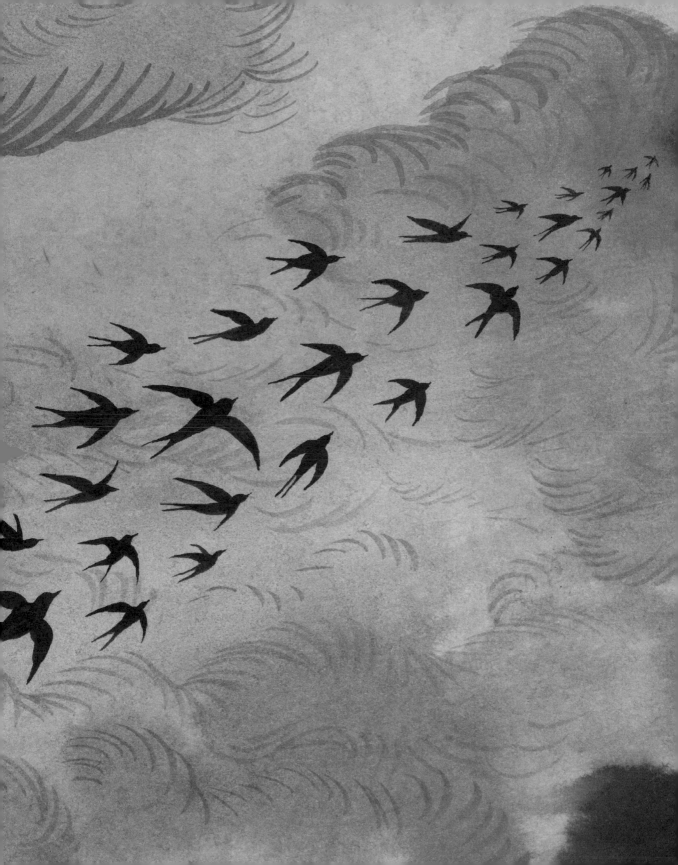

PATTING A FRIENDLY DOG

This is Diesel. He lives on the neighboring farm, but he often comes to visit. We look forward to seeing him, even though he's always wet and smells like skunk. We walk him home and then he walks us home and we walk him home again. And on the way we talk about chasing rabbits and rolling in burdock. When you pat him, he leans against your legs and smiles.

And then we smell like skunk too.

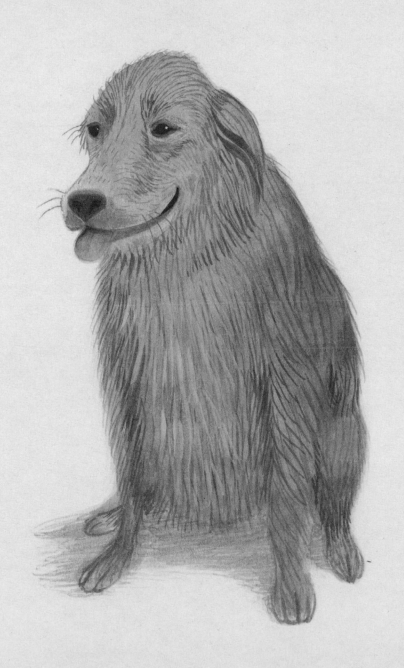

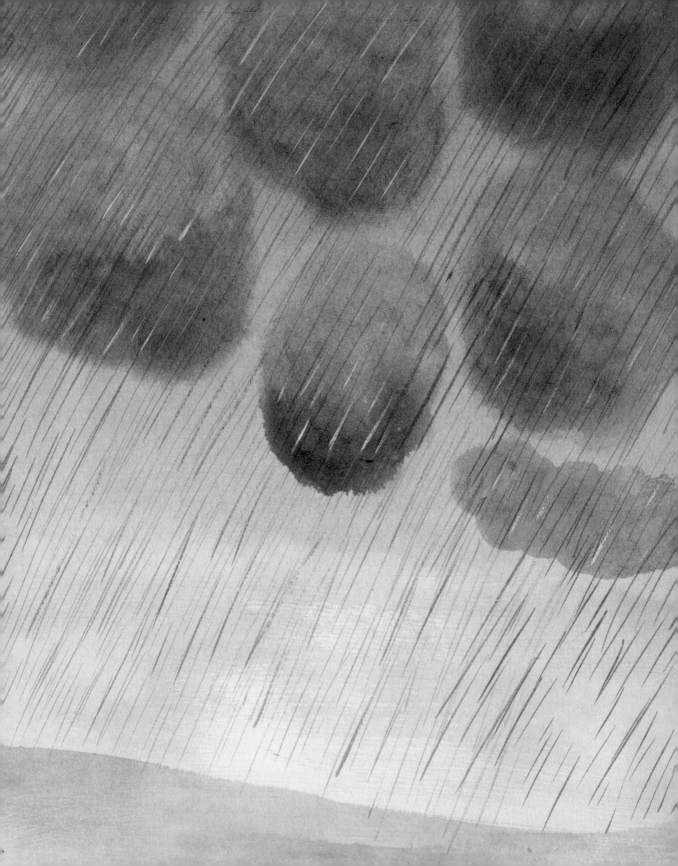

RAIN

Sometimes we might not wish for rain, when we have just blow-dried our hair or cut a field of hay. But mostly we can look forward to the rain, to water the seedlings, to swell the streams, to fill the tanks and put out the fires, to wash the world clean. Inside the house we might turn on the lamps and watch raindrops trace patterns on the windows, but if it's been a long time since we've seen the rain, we might run out into the downpour and lift our faces to the sky.

RAINBOWS

If we are lucky, when the rain has stopped and a fine mist hangs in the air, sunlight might enter enough tiny droplets, bend as it hits each surface, bounce off the back wall of the raindrop, and bend again as it exits. And if we happen to be standing facing away from the sun and raising our sights 42 degrees, that refracted, reflected, dispersed light might form a shimmering rainbow. Then we can make a wish.

 We can also paint our own rainbow and hang it in the window, or get a flag and wave it in the street, to remind one another that love is love and the world is full of beauty and there are always things to look forward to.

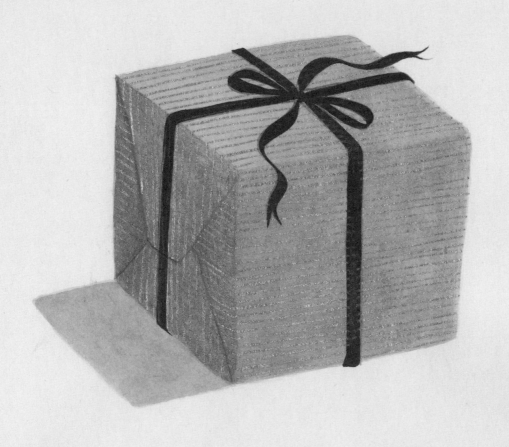

NOT OPENING A PRESENT

Many years ago, I made a difficult decision that I knew was right but also knew would hurt the people I loved most in the world. The early weeks and months of the separation were sad and dark and lonely. One day, in a little neighborhood shop, I saw a tiny bubble of a vase, made by a glassblower with a single breath. The shopkeeper asked if it was a gift and I said yes, even though I wasn't going to give it away. She wrapped it with care in a little box with a black ribbon.

I put it on my dresser, where it remains, fourteen years and three homes later, unopened. I look forward to not opening it for years to come.

A FULL MOON

Wherever we are in the world, we see the same moon. It's the same moon earliest humans would have seen, waxing and waning, rising and setting. Depending on where we were thousands of years ago, we would look to a full moon to mark time, to tell us when to plant corn, when to lay the rice to dry, and when to expect the ducks back. Now we look to the moon and marvel that men have traveled there in unlikely contraptions and actually set foot on its surface. It is our stepping-stone to the vast universe, and looking at a full moon can make us feel very small and very young. But it can also remind us to make the most of our time here on earth, to pop corn and throw rice and watch for ducks.

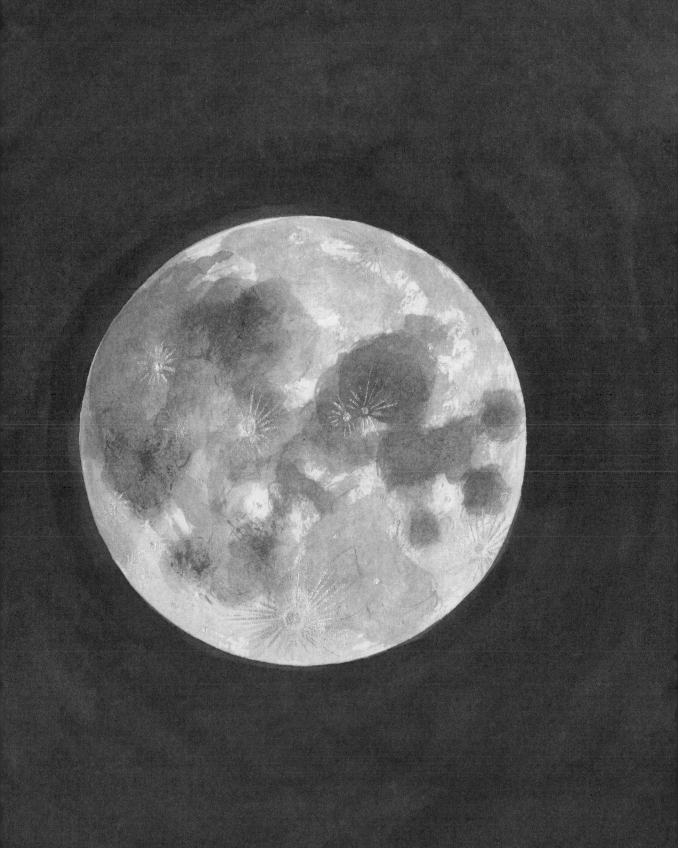

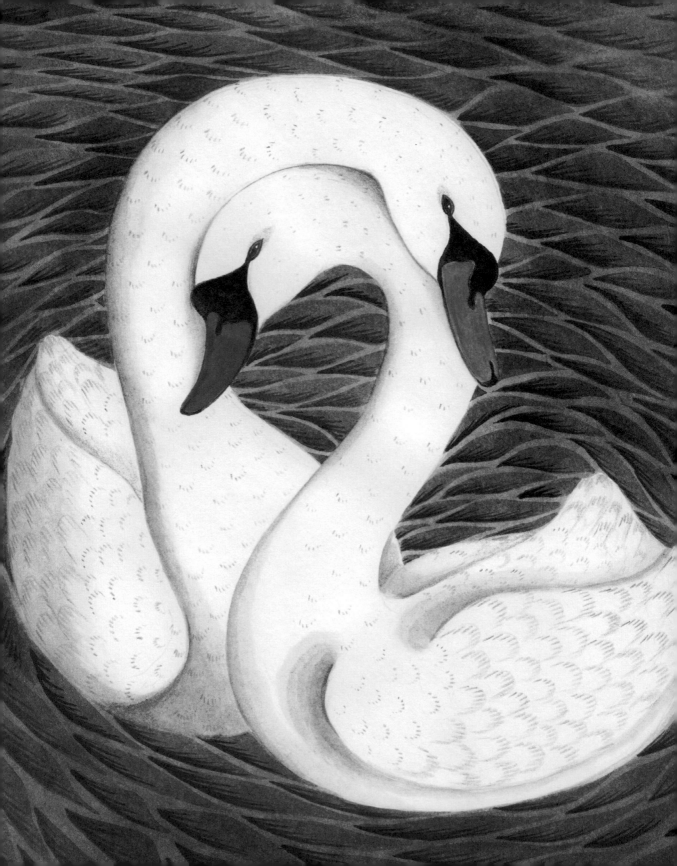

WEDDINGS

It's nice to have a wedding to look forward to. The first wedding in which I had a proper role was a long time in planning. Kylie and Fiona were the happy couple, and they wore their best dresses. Ann brought the cake, and I threw the rice. It was brown rice. We were in fifth grade. I've loved every wedding I've attended since then: the awkward speeches and the great ones, the drunken uncles and the wardrobe malfunctions, the unions you fear won't last a year and the ones you feel will last forever. But it's been a while. There's been a wedding drought. So Ed and I decided to get married. We chose a field and sent out invitations and made a playlist. I began to sew my dress. And then a virus came and stymied our plans. But the field is still there. The needle is stuck in the hem where I left it. The guest list waxes and wanes. We don't know when we'll get married, but we're looking forward to the wedding.

BABIES

They're everywhere! New babies every day and more on the way, each a bundle of hope for a better future and each a reminder of our responsibility to try to give it to them.

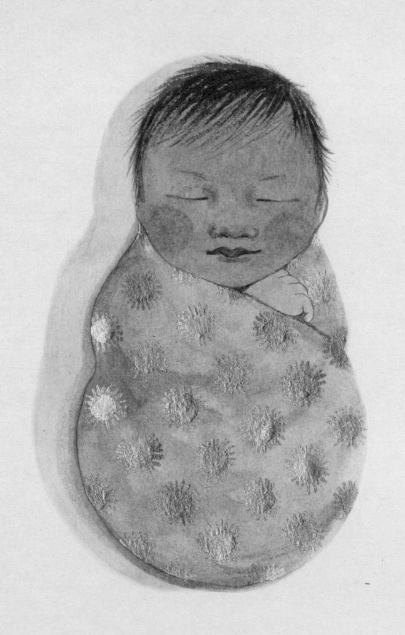

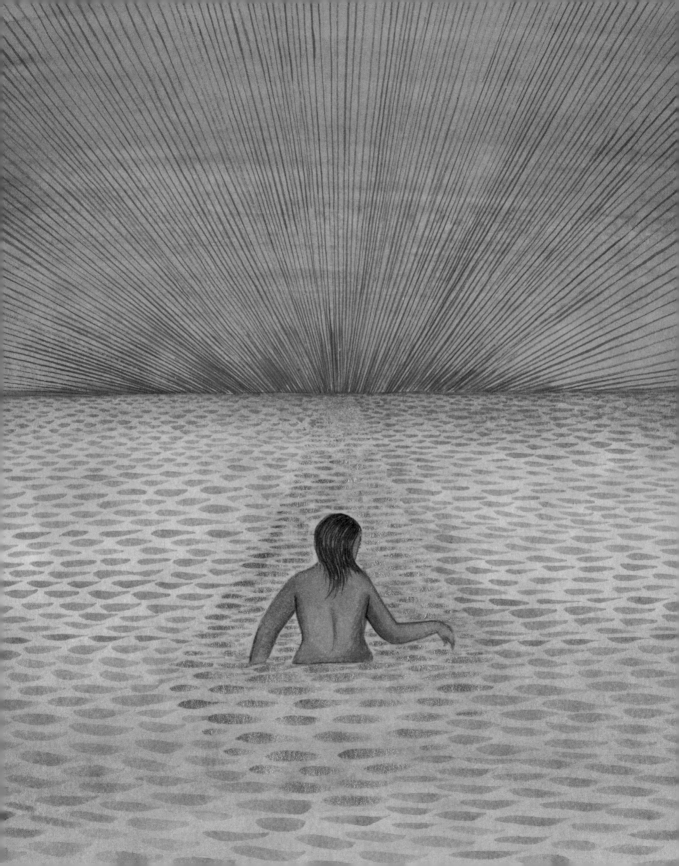

SKINNY DIPPING

Before we were born, we floated naked in warm waters; then we grew up and put on clothes. Most of us spend the day with our bum on a seat and our feet on the ground, but we can dream of being naked again in a body of water. If the opportunity presents itself to shed our clothes and jump into an icy stream on a mountain hike or to dip into the balmy sea in the rosy dawn, we ought to take the plunge. We'll find a flat rock and leave our shoes and wallet and keys and phone and fear and shame behind, turn our back on them, and slip into the water. They'll be there when we emerge, tingling and ecstatic, and maybe we'll just retrieve the things we need.

NEW GLASSES

When my child got their first pair of glasses at the age of nine, they didn't realize most people were able to see individual leaves on trees. They thought everyone saw them as fuzzy shapes.

 As my eyesight deteriorates in middle age, I look forward to new glasses that actually stay on my face and allow me to see things more clearly. Sometimes the world looks better fuzzy, but it's nice to have the option. And to be able to thread a needle.

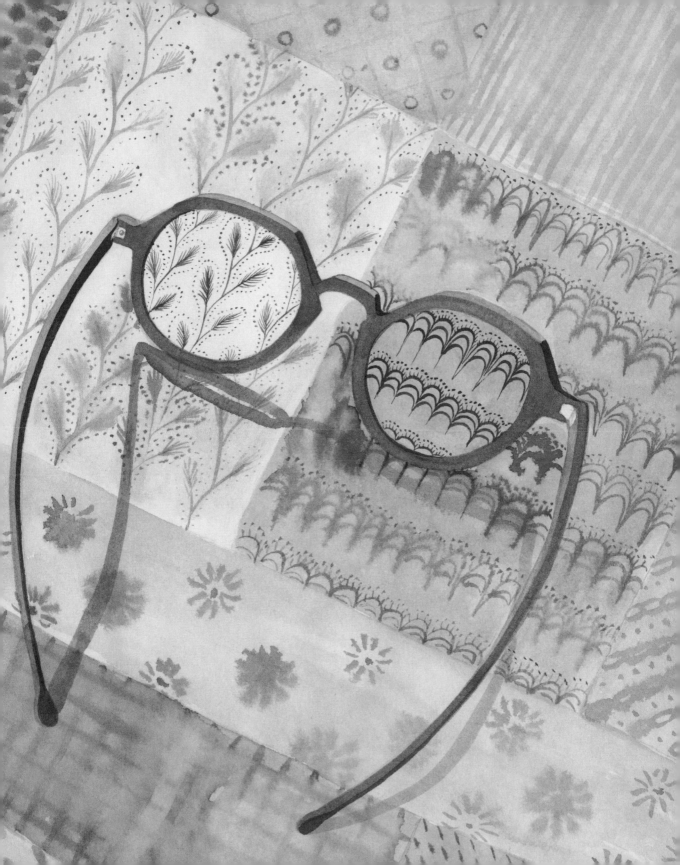

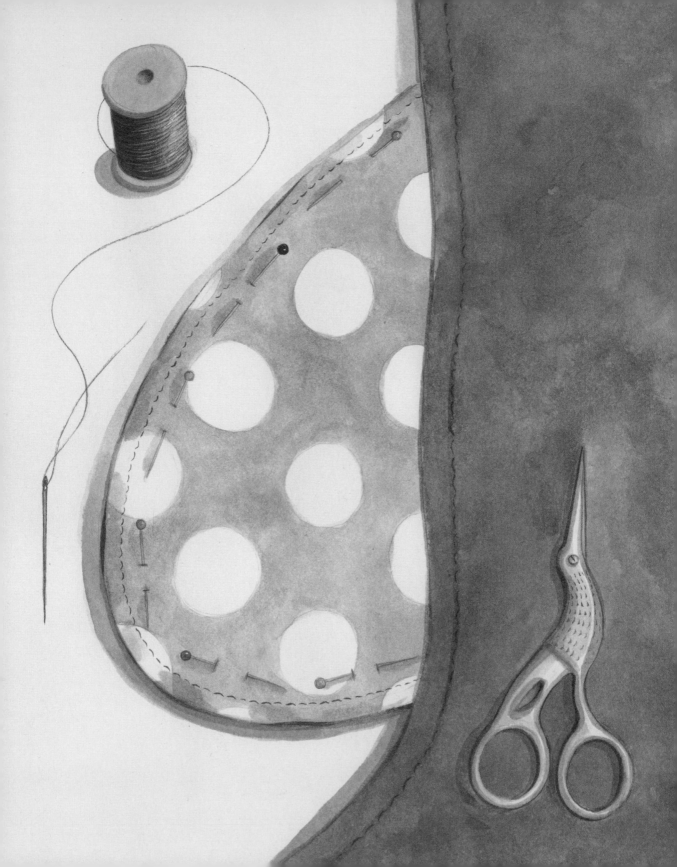

MENDING A HOLE

My favorite coat is an old, worn, velvet thing, the color of lint, but it has silky, chartreuse polka-dot pockets. Both pockets have holes in them, which I've worried at with restless fingers until the pockets have become chutes. Anything put in them falls straight through and is often lost—keys, coins, horse teeth. But now that I can see to thread a needle, I'm looking forward to mending those holes. It's not a metaphor or anything; it's just going to be nice to be able to collect things in my pockets on a stroll in the woods or along the shore.

COLLECTING PEBBLES

Whenever I travel, I look forward to collecting pebbles: fossil-studded ones from the beach where I grew up in South Australia. Smooth, green, stackable disks from a cove on the Greek island of Folegandros. Pitted black lava from the slope of a volcano in Iceland. I return with bags and pockets weighed down with stones, each one a voyager with a long, mysterious history, each one a treasured memento of a more recent adventure.

But I live with someone who, much as he appreciates pebbles, believes that there is a limit to the number of pebbles you can keep in a home. That number is 288, apparently. So if you have more than 288 pebbles, you can give them away. But first you can paint whales and comets and rabbits and moons on them.

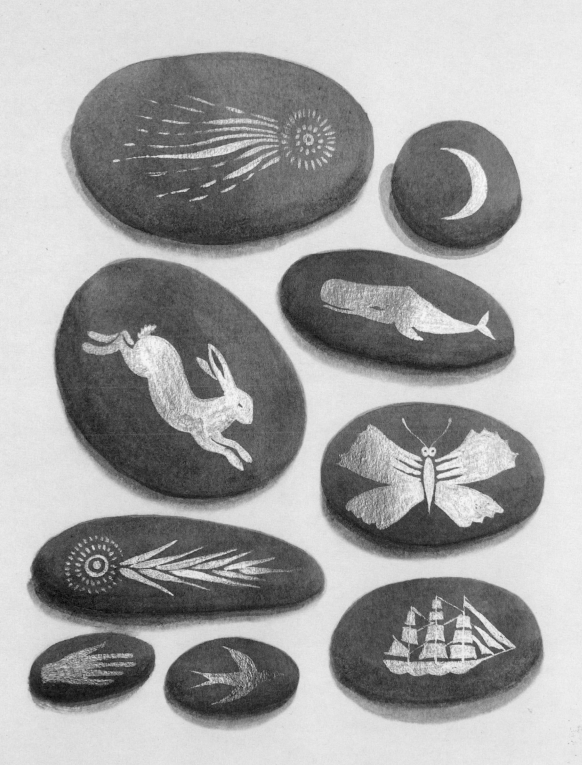

SEEING THE SEA

I grew up by the sea. My mother and brother would walk the length of the beach most days, and I'd watch them become specks in the distance as I stayed on my own by the shoreline, drawing in the wet sand with a stick. Or I would build cities with elaborate canal systems or line up pebbles and shells in enormous spirals or arrange clumps of seaweed to spell out HELLO. I was consciously making offerings to the sea. It made me happy to watch the tide come in and take them away.

And yet here I am, living in the mountains, far from the coast. I have come to love the woods and hills and streams, the wildflower meadows and fieldstone walls, but I look forward to seeing the sea. I'm like a dog in the back seat of a car approaching the coast, whimpering and sticking my head out the window to gulp the air. I want to run into the waves, fling myself on the sand, sigh at the horizon, and fill my pockets with pebbles.

If I am too long away from the sea, I get all out of sorts, like Herman Melville's Ishmael: "Whenever I find myself growing grim about the mouth; whenever it is a damp, drizzly November in my soul; whenever . . . it requires a strong moral principle to prevent me from deliberately stepping into the street, and methodically knocking people's hats off— then, I account it high time to get to sea as soon as I can."

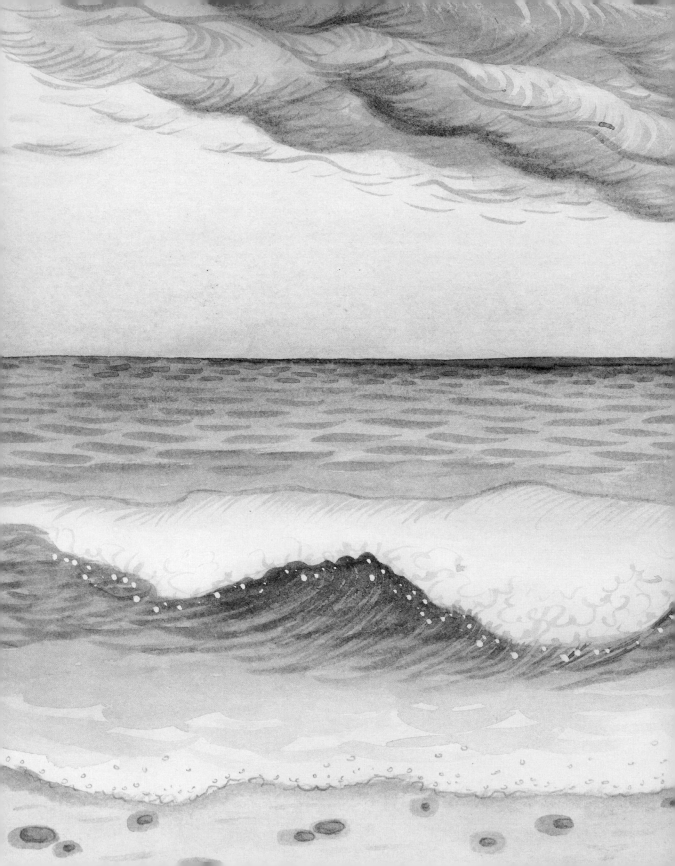

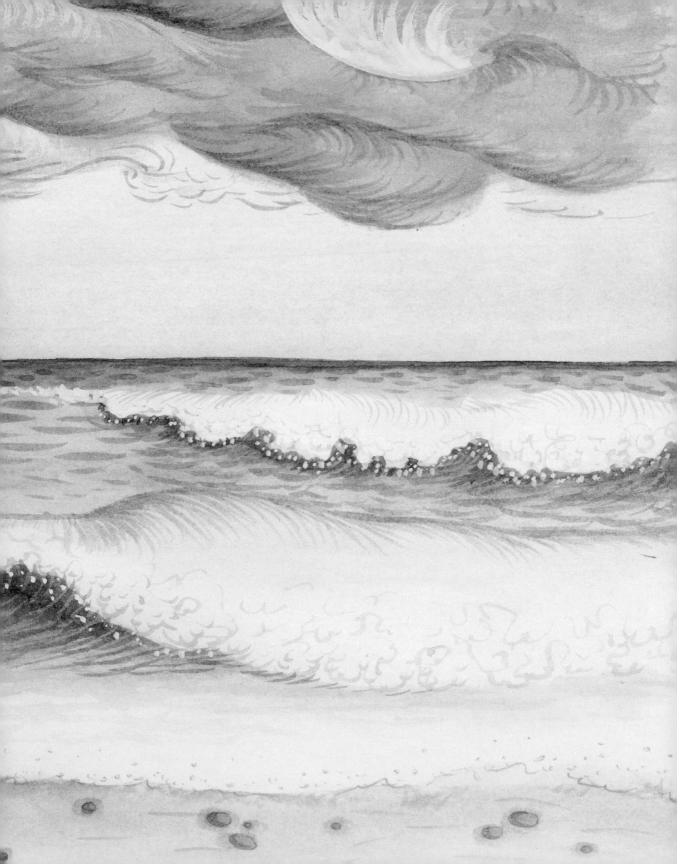

REREADING FAVORITE BITS
OF A FAVORITE BOOK

There is enormous comfort in beloved, familiar books. New books are exciting, but in times of need, I turn to old friends. They're always there when you need them.

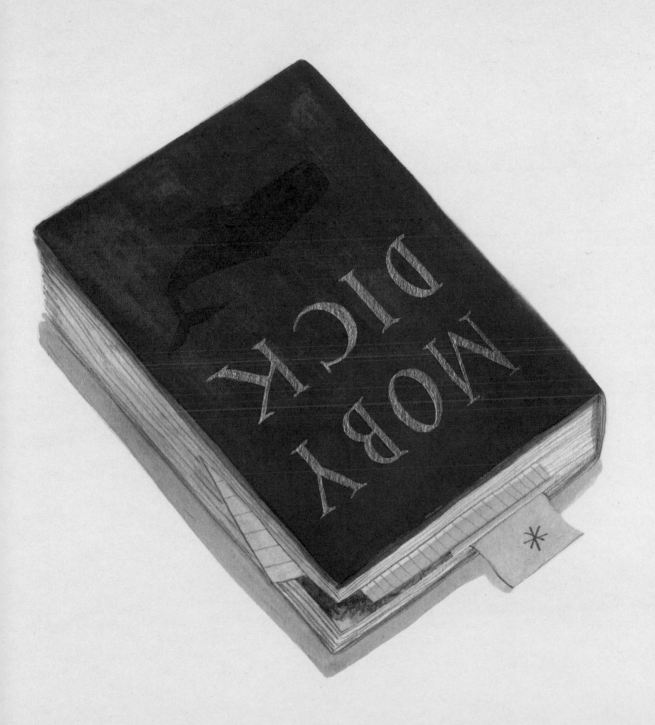

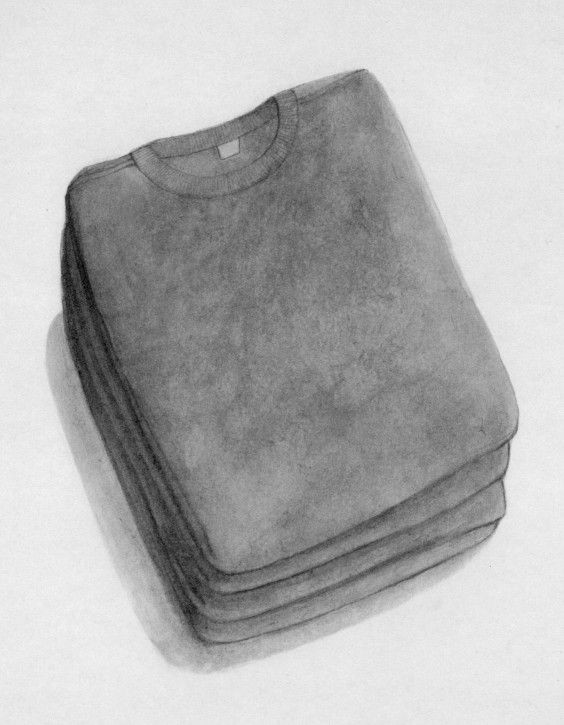

CLEAN LAUNDRY

I tend to put off washing clothes until the last possible day, when I'm reduced to leggings with holes and the mustard top that inspires people to ask if I'm feeling OK, but clean laundry means a whole closet of possibilities. I can dress like a nineteenth-century French farmer or an Edwardian ghost or a deckhand on a whaler off Nantucket. Actually, those are pretty much my three options, but there are many subtle variations.

My clothes are pre-owned, unruly, and difficult to fold, but my partner wears a uniform. Not the kind with epaulets or creased slacks or his name embroidered on his chest, but a deliberate, self-selected uniform. Ed is a playwright and a teacher, and he heeds the advice of Gustave Flaubert: "Be regular and orderly in your life, so that you may be violent and original in your work."

Once a year, he purchases six gray T-shirts and a dozen pairs of black socks and multiples of carefully chosen, unremarkable shirts and pants. On laundry day, his neatly folded piles of clean clothes are so dear and familiar they put a lump in my throat.

MOVING THE FURNITURE AROUND

My grandmother, who never went on vacation, used to say, "A change is as good as a holiday." Every time we visited her, we would find the living room reconfigured. There's something to be said for moving furniture around. For one thing, it forces you to sweep under the couch, and maybe you'll find something you thought was lost. It also makes you see things that had become invisible to you. It changes your perspective. Sometimes Ed and I switch sides of the bed. Sometimes we turn the bed around. Do we dream differently lying north-south than we do lying east-west? There's only one way to find out.

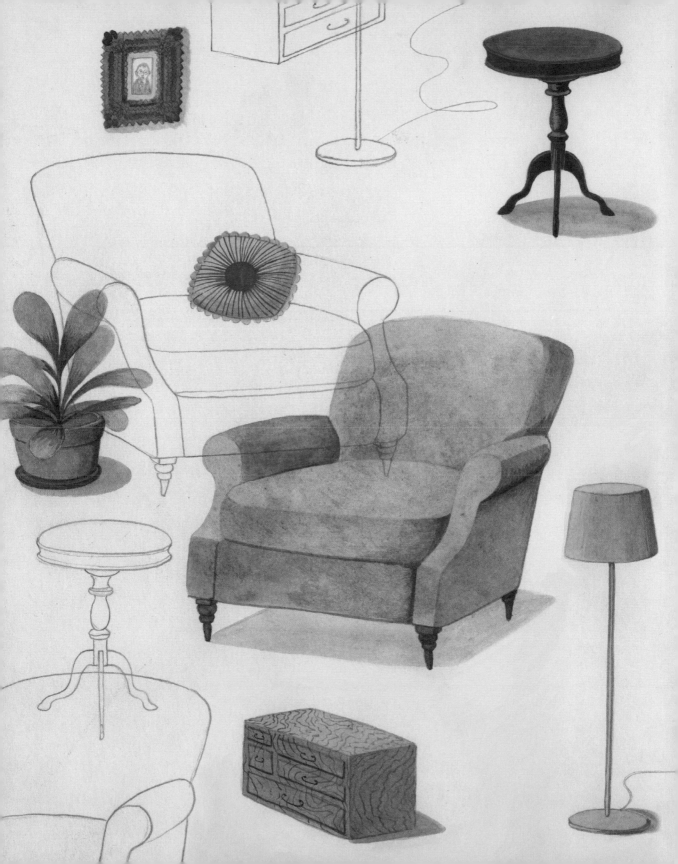

FINDING SOMETHING YOU THOUGHT YOU'D LOST

I am a loser of things. Not everyday things, like a phone or keys, but things I care about. I have no earthly idea where the deed to my house is, for instance. A few years ago, I was given a medal, a medal that meant the world to me, a medal that I promptly lost. What's worse, I didn't even realize I'd lost it until I was asked to pose with it for a photograph. It wasn't that I'd carelessly misplaced it; it was that I'd carefully stored it away. I just couldn't remember where. Part of the problem is that I collect things, like pebbles and strangers' photo albums from previous centuries and German porcelain dentures and sorry dolls made from old socks. I'm good at finding other people's things. My own lost things worry at me and keep me awake at night until one day I can't stand it anymore, and then I turn the house upside down until I find them. (The medal was in a box in a bag in another bag.) The relief at finding a lost thing is enormous: a great, warm rush of gratitude. We moved house recently and found all sorts of lost things. But moving is a bit extreme. Usually, a good tidy up will do.

TIDYING UP

Much of the world has been swept up in the magic of tidying. People have reorganized their sock drawers and their entire lives. Not me. But I do look forward to a good tidy up now and then: to unearth lost things, to clear a space for the next project, to temporarily restore order, to notice treasures that had become invisible, to purge possessions that have served their purpose, to arrange vintage erasers by size and shape. Having friends over for dinner is a good excuse to tidy up—and is something to look forward to in itself.

DINNER

I learned to cook when I was at college, living with my father and stepmother, Diane. At breakfast, Diane would say, "What should we have for dinner?" And we would look forward to it all day. Some mornings she would already have stock simmering or pastry chilling or lentils soaking. In the afternoons I'd return from class to help roll pasta and fold tortellini, to weave strips of blanched leeks and twist parchment paper into cones to pipe meringue onto baking sheets. Sometimes the answer to "What should we have for dinner?" would be "Scraps," and we'd look forward to leftovers from the night before.

But what I really look forward to is a dinner party, the kind of dinner that sprawls into the wee hours and leaves a table strewn with crumpled amaretti papers and a champagne wire chair. The kind of dinner where conversations meander and stories are told and secrets are revealed, where dear friends doodle as the candles burn down and the next morning you find the candle wax molded into lumpen rabbits.

VISITING A MUSEUM

From the time we first began sharpening stones and gathering shells, mixing paint and drawing in caves, learning signs and burying our dead, humans have made decisions about what should be kept and what should be documented, what stories to tell and who should tell them. One of the things that sets humans apart from the rest of the animals is our ability to contemplate past, present, and future. We are beginning to look backward for the untold histories and forward to ensure all voices are heard.

In the meantime, we can visit familiar museums, where we can encounter old friends and find them exactly as we last saw them while also recognizing that we see them differently each time because we ourselves are different. In Manhattan, I look forward to visiting the taxidermied moonlit wolves perpetually leaping through the snow in a shadowy corridor at the American Museum of Natural History; or Meret Oppenheim's *Object*, the fur-covered teacup, saucer, and spoon at the Museum of Modern Art, the postcard of which I had stuck on my teenage bedroom wall; or Irwin Untermyer's bed at the Metropolitan Museum of Art, where the fictional runaway children from the book *From the Mixed-up Files of Mrs. Basil E. Frankweiler* once slept.

We can visit a museum that celebrates the hammer in Alaska, mustard in Wisconsin, or UFOs in New Mexico. We can visit museums that change our lives, like the Secret Annex in Amsterdam where Anne

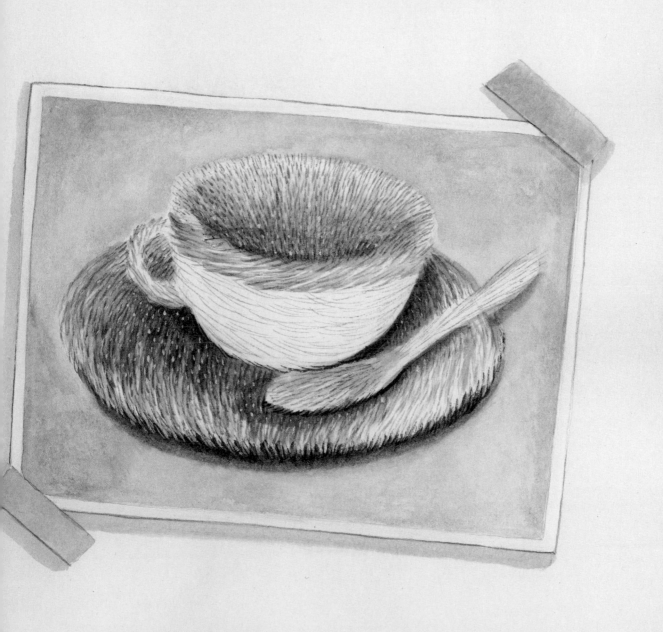

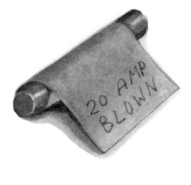

Frank's family and their friends hid from the Nazis for over two years, or the Kigali Genocide Memorial in Rwanda, which shelters the remains and names and snapshots and blood-stained clothing of some of the eight hundred thousand children, women, and men who were brutally murdered in 1994.

We can look forward to new museums that open up our worlds and challenge our complacency and tell stories that have been too long over-looked. We can also build repositories in our homes of collections and mementos. Nick and I found a carefully labeled blown fuse in his dad's shed, and we pocketed it as a funny souvenir of a dear and thrifty man. Decades later, it is still a prized possession, more so now that both Nick and Jim have passed away. This tiny object is a mnemonic device for a place and a moment and two men and our interwoven lives.

The museums we create tell the story of who we are and the people we have loved.

FINISHING SOMETHING

I have sometimes thought that if I didn't make books, I would open a Museum of Unfinished Projects, housing things like a cross-stitch sampler that reads HOME SWEET HO, or a matchstick model of the Eiffel Tower, paused at the deuxième étage. Ambitious projects launched with enthusiasm, cast aside for unknown reasons, enigmatic in their limbo. I wouldn't have to look far to furnish such a museum. I have my own Cupboard of Shame, stuffed with knitting that proved too complicated, or too small for the recipient; the three quilt squares waiting for the other thirty-three; the bag of stripped rags that I imagined braiding into a rug. But there's real gratification to be found in finishing things. Fitting the final piece in the jigsaw puzzle that has taken over the dining table for weeks. Taking the last tablet in a course of antibiotics, allowing you to resume your evening cocktail. Reading the final sentence of a book, extracting the last smear of toothpaste from the tube, staggering across a marathon finish line, ending a relationship that has run its course. Finishing something means that you can begin again, and that's something to look forward to.

FALLING IN LOVE

I met my husband, Nick, when I was twenty-one, and we moved in together before the year was out. We got married when I was twenty-five, and I had my first child at twenty-six. But I didn't fall in love, not properly, until I was thirty-six. And it wasn't with my husband. It wasn't that Nick and I didn't love each other. We did. We were best friends. He could play "My Funny Valentine" on his teeth and make anything out of nothing: a 1930s-style playhouse, a shirt out of a vintage tablecloth, Halloween costumes that made the news. He had a blinding temper, but he was as funny as he was angry, so I laughed at least as much as I cried. When we met, he thought he was 5 percent gay. It turned out he was 5 percent straight. But that was enough to make two excellent children, and we thought we were happy.

Days with young children can pass by in a blur of drop-offs and pickups, bath time and bedtime, Hot Wheels and carrot sticks and Shrinky Dinks. If you're in love with your partner, I can imagine finding moments to notice each other, managing, even through the blur, to see one another clearly. But if you're not sure, then you can become kind of blurry yourself.

Later, when I met Ed, the man I would fall in love with, I was still a bit blurry, but I saw him in distinct detail. I noticed everything: his beautiful profile, his generous ears, his kind eyes. The way he shoved his T-shirt sleeve up on his handsome shoulder as he talked. His heartbreakingly

neat handwriting. The way he was always reading, even when he was walking down the street, underlining without breaking stride. The way he carried everything in a stack: book, extra book, notebook, pen, phone, as though he'd never heard of bags. The way he followed a recipe and put all the ingredients in little bowls. The way his tongue stuck out when he chopped onions or dribbled a basketball or tied a child's shoe. The way he made all the babies laugh. The way he made me laugh. The way he made my hands tremble.

And I noticed the way he noticed me too. He saw me more clearly than anyone had, ever before.

And bit by bit, I realized that I'd previously had no idea, no idea on earth, what it was to be in love and to be loved in return. Those were heady days. Fourteen years later, they still are. The point is, of course, that you can look forward to falling in love with the love of your life, day after day. If you haven't found love yet, or found it and lost it, then it can find you, perhaps when you least expect it.

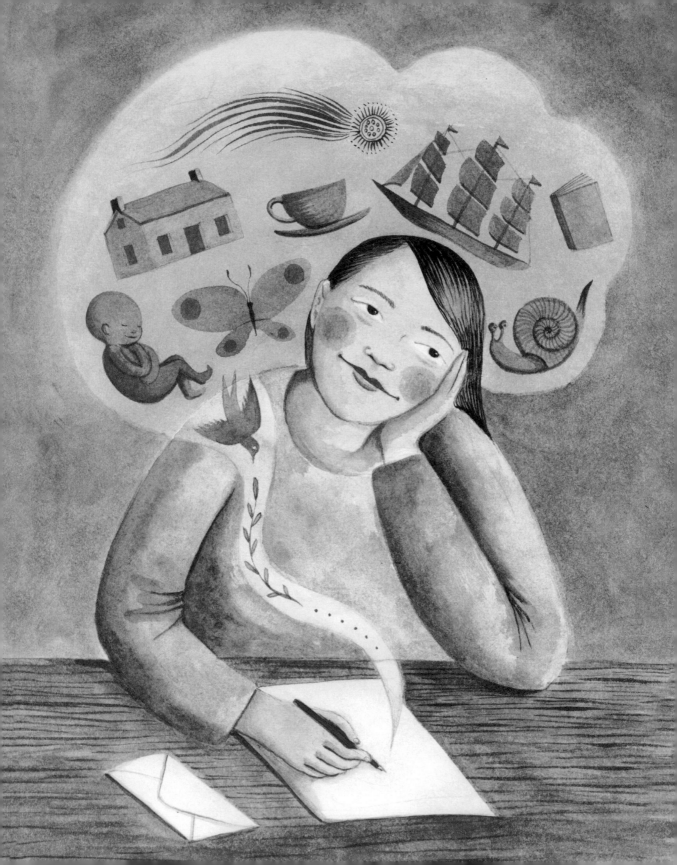

WRITING A LETTER

The pandemic reminded many of us of the joy of sending each other things in the mail. We crave tactile connection. If we can't see each other or touch each other, we can write something by hand and imagine it arriving in someone else's hand. We dash off electronic messages all the time, but when we sit down to write a letter, we think more about the person reading it. Will they rip it open and read it right away? Will they put the kettle on and take their time? Will they write back?

RECEIVING A LETTER

Before my grandmother died, she wrote and addressed all the birthday cards for the coming year. My mother discovered them in a shoebox and posted them, so we had the rather extraordinary experience of receiving her letters after she was gone. They all said the same thing— "Happy Birthday, love Oma"—but seeing her handwriting was enough. Emails and texts are great and all, but they don't give off the scent of Earl Grey tea or woodsmoke. They don't enclose gum leaves, like the ones my mother sends from the tree in her yard; or vintage swizzle sticks, like Dona Ann sent me from Vermont; or a small parcel of sand from a beach I've never seen, sent from a friend of a friend to that friend, who divided it in half and mailed some to me, so we might let it run through our fingers and dream of being there.

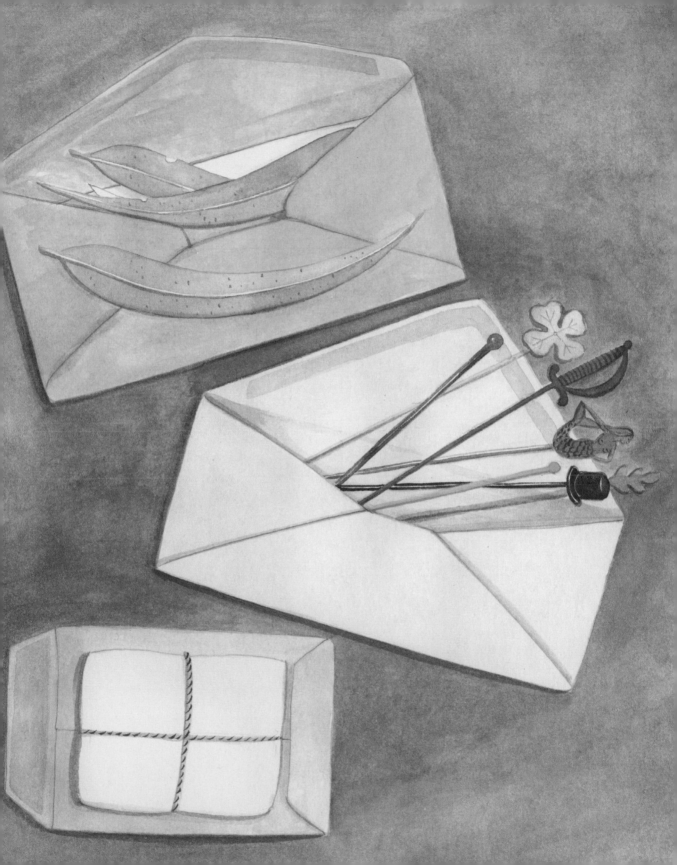

FEEDING THE BIRDS

My mother moved to a new town just before the world shut down, and spent most of the year in isolation. Every day she put out food for the birds, and soon they came: the wild doves first, then the magpies and cockatoos. She talked to all of them and told them to bring their friends.

My cousin Tom lives a life in which he is surrounded by people but gets up earlier than most and sits patiently, with an outstretched hand full of mealworms, until fledgling robins land on his fingers.

We keep a bird feeder with black sunflower seeds and another with red nectar. We watch the flitting and swooping of goldfinches and blue jays, nuthatches and warblers and woodpeckers, not to mention the entertaining battle between squirrels and chipmunks after the seed. But one summer evening as I read my book in a garden chair, I heard a buzz and held my breath and saw the flash of a hummingbird hovering above my head: a tiny, iridescent marvel. I look forward to its return.

WORKING UP A SWEAT

Ed made me write this one. He assures me that many people look forward to regular exercise, that it is beneficial to our physical and mental well-being. He has explained endorphins to me and extolled the pleasures of running or cycling or playing a pickup game of basketball. Other friends look forward to their Zumba class or twenty-four-hour cardio dance parties or jogging with their dog. My stepmother gets up at dawn and swims in the ocean, no matter the weather.

Mostly I like to sit at a table and make things with my hands. But when there's work to be done—shoveling snow or stacking firewood or building a drystone wall—I'm there. I like a goal and the reward of completing a task, and I'll concede that getting sweaty and dirty and thirsty is part of the pleasure. Especially when you can look forward to a hot shower, clean laundry, and a drink of water.

A DRINK OF WATER

When I'm cold, or caught in a rainstorm, I look forward to feeling warm and dry. When I'm tired and grumpy and weepy, I can hardly wait to crawl into bed, and when I'm hungry, I think longingly of toast. But when I'm thirsty, truly parched, there's nothing I look forward to as much as a drink of water. I live in New York in the twenty-first century; I don't have to carry my water from the well as they did in ye olden days, or as they still do in many parts of the world, like Burera, Rwanda, for instance. I don't have to worry that the water is poisoned with lead and will make my children sick, as parents did in Flint, Michigan, and I don't have to face the fact that the dam has dried up and there's no sign of rain, like people have done in Guyra, Australia. Most of the time, all I have to do is turn on the tap.

But now and then I find myself without water, like on a poorly planned mountain hike. We had camped overnight in relentless rain and woke bruised and sodden. We set out the next morning, determined to reach the summit, a couple of inches of water left in our flasks, confident we'd cross the stream sooner or later. We did not cross the stream. We climbed and climbed. The day grew warm. We began panting. I searched the leaves for condensation. The ground for puddles. And then, just as we were truly raspy and desperate, we found a trickle of cool, clear water sliding over a rock face. It took forever to fill our bottles, but every sip was like some extraordinary elixir from the center of the earth.

A NAP

Many of us have forgotten how to sleep. There's much to keep us awake. The repercussions of a global pandemic. Our endangered planet. Nations in crisis. Communities divided by politics and inequality. Unemployment. Medical bills. Encroaching tax deadlines. Families separated at borders. Children without lunch. Without books. Without shoes. Things we shouldn't have said. Things we didn't say. Emails we haven't answered. Things we've lost and cannot find. The lump that's probably nothing. The notice we've ignored about the airbag recall on our old station wagon. The fact that the overpriced avocado that was rock hard yesterday is probably too ripe by now and will have to be thrown away . . .

 Some of these things are out of our control. Some we will approach and tackle and resolve. Others we will have to learn to accept. We hope we will remember how to sleep again, and even to dream. In the meantime, we should be kind to ourselves and try to find time for a restorative nap.

DOING YOUR TAXES

Like many people, I fear and loathe paperwork. My desk has sedimentary layers of invoices and receipts, and now and then a great sheaf of papers slides to the floor, like an iceberg calving into the sea. I dread doing my taxes even more than I dread visiting the dentist. And yet I look forward to it too. The moment after filing my tax return, the relief is so great I feel like I could take flight.

VOTING

If you live in a democracy, chances are you have the right to vote. You have the opportunity to make your voice heard. You can vote for equality. For civil rights. For human rights. Vote for the planet, for the forests and oceans and glaciers. Vote for women's right to choose what to do with their bodies. Vote because Black Lives Matter. Vote to protect our essential workers and first responders. Vote for a living wage. Vote for our LGBTQ+ friends and family, that they may be safe and free to live with respect and dignity. Vote for dignity. Vote for honesty and civility and decency. Vote for the displaced and homeless and for those who can't vote. Vote because you can.

GROWING YOUR OWN FOOD

Whether you have a pot of chives on your window ledge or have built a raised vegetable garden from scratch, you know that eating something you've grown yourself is thrilling. If you've thought about it but haven't gotten your hands dirty yet, may I say that sprinkling tiny seeds of arugula into the soil is ridiculously easy, and harvesting the fresh, peppery leaves just a few weeks later is absurdly rewarding. And when you are fully obsessed, braiding your onions and soaking your tomato seeds and drying the last peas that cling to the vines to plant in the spring, you are literally storing up things to look forward to.

LOOKING AT MAPS

I like all kinds of maps. Meander maps that show the serpentine twists and turns of a river over the years. Maps of the palm of your hand or the surface of the moon. City maps that show where there was once a canal but now just a street that bears its name. Battle maps. Relief maps. Treasure maps, obviously.

My father had an enormous atlas on a stand that we used to pore over together. He would show me the route he traveled across Siberia in 1966, working his way through Mongolia and China on his way to Japan.

When Nick and I were courting in the early '90s and planning a road trip, we opened a map of New South Wales and, closing our eyes and jabbing a finger, landed on a protruding squiggly bit of coastline north of the city. It was pre-internet, so we knew nothing about the place other than its promising contours and its excellent name, Delicate Nobby. It lived up to both.

The last time I visited my friend Meg in London, she drew me a map of the most interesting way to walk to the Tube station. I had a phone that could tell me the quickest, most direct way, but it didn't have little drawings of the Ladies' Bathing Pond in Hampstead Heath or the grave of Douglas Adams.

We can look at a map to help us find our way or remember where we've been or imagine where, if we could go anywhere in the world, we might go.

WALKING IN CEMETERIES

I walk in a cemetery to remember the dead, to peer into the mausoleums, to admire the mossy stone angels and weep over the tiny lambs. You might go to visit loved ones or to wander the gardens, to watch for birds, to look for names—for a child, a pet, a character in your novel. Either way, it's hard not to leave a cemetery feeling alive and happy to be here on earth, grateful for the brief time allotted us, isn't it?

GOING SOMEWHERE

If we are lucky, we can look forward to leaving our regular lives behind for a while. We might pack a few belongings in a suitcase and go somewhere else for a change of pace, a new perspective, a different scene. We might take a train to the next town or chase the northern lights across the Arctic Circle. We might try Nathan's Famous hot dogs on the Coney Island boardwalk or river-weed soup on a mountain pass in Bhutan. We might retrace the steps of our immigrant ancestors or cross an ocean to adopt a child or drive an hour to spend time with our mom. But no matter where we go—or how we get there or who we meet or how long we stay away—sooner or later, we will look forward to coming home.

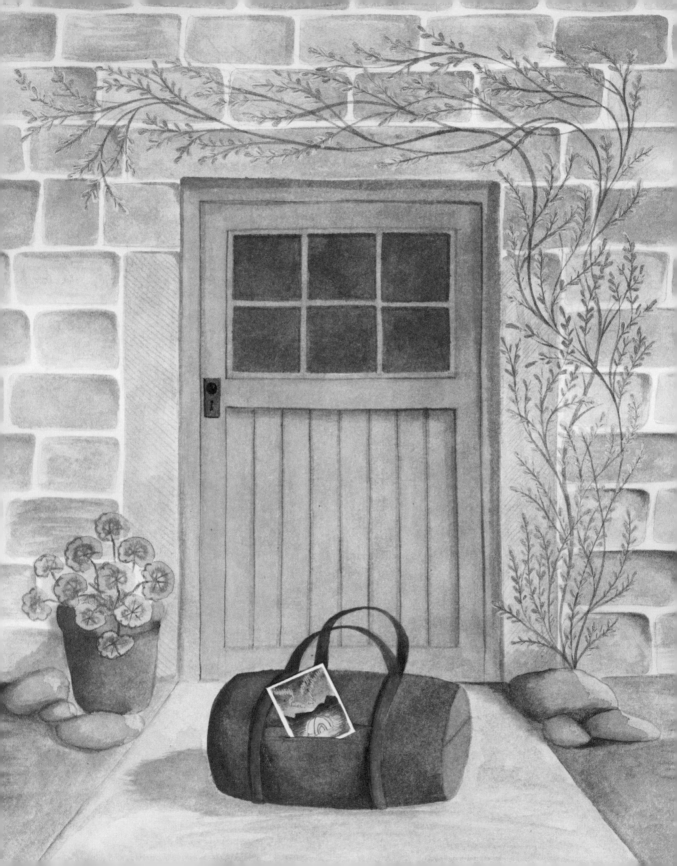

COMING HOME

It is a wonderful thing to travel and see the world, and an even better thing to come home. To unlock the door and drop your bags and do your laundry and open your mail and put on the kettle and make—or not make—tea. To kick off your shoes and take a hot shower and climb into bed and rest your head and pick up your book and read half a page and fall fast asleep and dream and dream.

MAKING A LIST

If you are in a rut, if you feel overwhelmed by gloom, if you are exhausted and uninspired and out of sorts, you can make a list of Things to Look Forward To. Simple things, everyday things. Things that don't cost much money. Things you can do without leaving the house. Things that bring you pleasure. Things that you don't want to take for granted. Things that may never actually happen but are fun to look forward to all the same. And if you make such a list, you can share it with a friend, or with me, and it might make us all feel better.

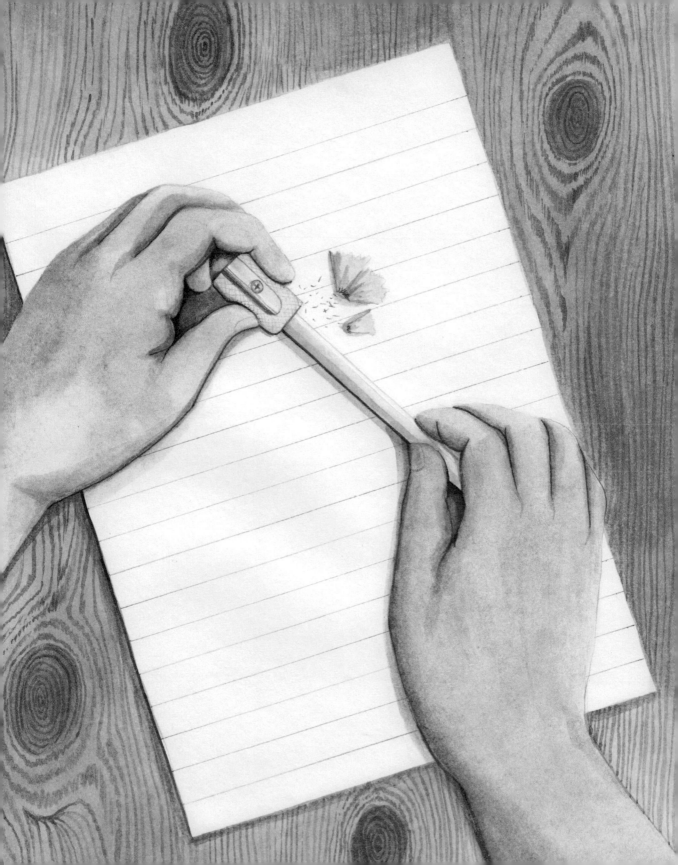

SEIZING THE DAY

For all this talk of looking forward, most of the things on this list can be done right now. *Carpe diem!* If we make the most of today, we will have a better future. If we view time as a gift, we'll be less likely to squander it.

If we look for beauty, we'll be sure to find it. If we help our neighbors, it will lift our spirits. If we finish something, we can begin anew. If we open our minds, we will expand our brains. If we vote, we can bring about change. If we plant some seeds, there's a chance they'll sprout. If we pick the flowers, more will come. If we use up our ideas, we'll think of others. If we remember the dead, we'll feel more alive. If we're kind to ourselves, we'll be kinder all around. And if all of this fails and it's one of *those days*, then there's always tomorrow. No matter what happens, the sun will come up. You'll see.